This is
Rembrandt

Published in 2016 by
Laurence King Publishing
361–373 City Road
London EC1V 1LR
United Kingdom
T +44 20 7841 6900
F +44 20 7841 6910
enquiries@laurenceking.com
www.laurenceking.com

ISBN: 978 1 78067 745 3

Series editor: Catherine Ingram
Printed in China

This is
Rembrandt

JORELLA ANDREWS

Illustrations by NICK HIGGINS

LAURENCE KING PUBLISHING

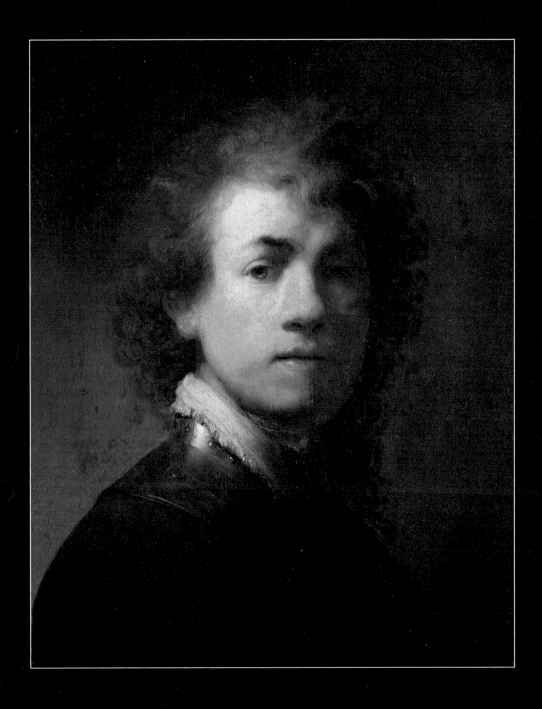

Self-Portrait with Gorget
Rembrandt, c. 1629

Oil on canvas, 38 × 30.9 cm (15 × 12 in)
Germanisches Nationalmuseum,
Nuremberg, Inv.: GM 391

Rembrandt van Rijn is the quintessential Old Master. His intimately observed, vivid and profoundly atmospheric works are what many museum-goers consider traditional painting ought to be. But in his own lifetime Rembrandt was not always so well regarded. The expressive honesty of his paintings and prints could evoke disdain as easily as admiration. For more than a century after his death his style was dismissed by many academically trained art theorists and critics. In the nineteenth century, however, he was championed by artists fired by the revolution and change of their times. For them, Rembrandt was a kindred, radical spirit, his paintings imbued with a truly modern ethos.

Born at the beginning of the seventeenth century in the Golden Age of the newly formed Dutch Republic, Rembrandt found early fame and great wealth as a painter, living with the opulence of a rock star. But he spent way beyond his means. When, midway through his career, public taste turned away from him, these combined factors proved ruinous. For the rest of his life he would be destitute, crippled by debt, the loss of patrons and the deaths of loved ones. Nonetheless, he continued to paint with the same passion. The art he produced in his final years is arguably his most enduringly sensitive and open.

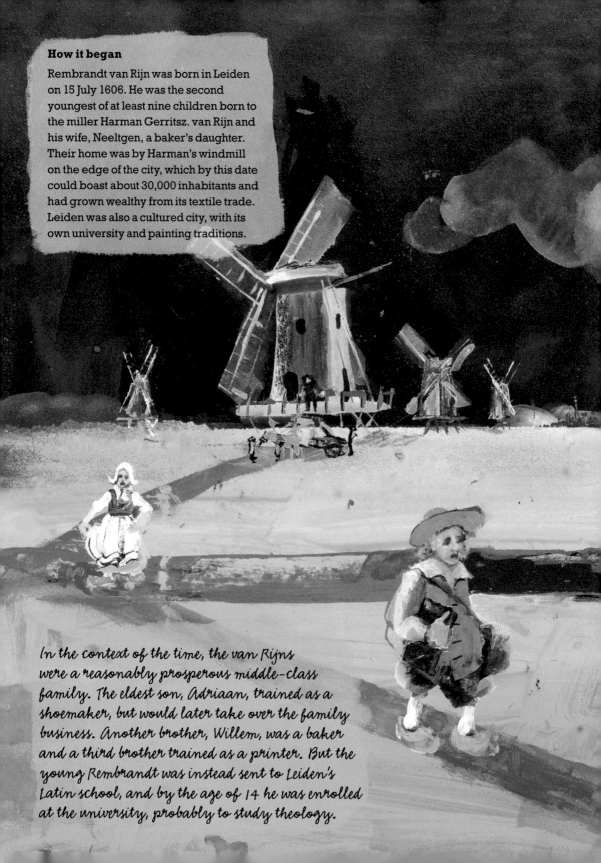

How it began

Rembrandt van Rijn was born in Leiden on 15 July 1606. He was the second youngest of at least nine children born to the miller Harman Gerritsz. van Rijn and his wife, Neeltgen, a baker's daughter. Their home was by Harman's windmill on the edge of the city, which by this date could boast about 30,000 inhabitants and had grown wealthy from its textile trade. Leiden was also a cultured city, with its own university and painting traditions.

In the context of the time, the van Rijns were a reasonably prosperous middle-class family. The eldest son, Adriaan, trained as a shoemaker, but would later take over the family business. Another brother, Willem, was a baker and a third brother trained as a printer. But the young Rembrandt was instead sent to Leiden's Latin school, and by the age of 14 he was enrolled at the university, probably to study theology.

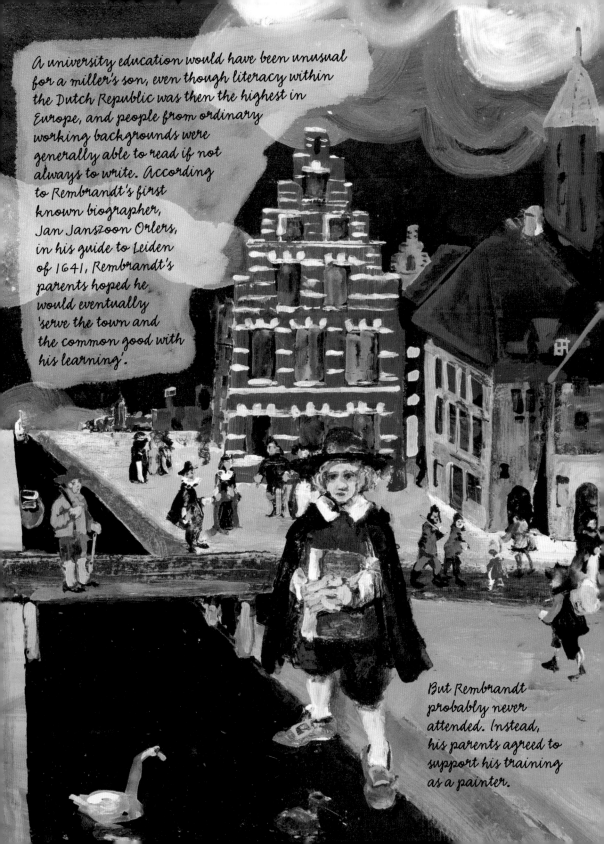

A university education would have been unusual for a miller's son, even though literacy within the Dutch Republic was then the highest in Europe, and people from ordinary working backgrounds were generally able to read if not always to write. According to Rembrandt's first known biographer, Jan Janszoon Orlers, in his guide to Leiden of 1641, Rembrandt's parents hoped he would eventually 'serve the town and the common good with his learning'.

But Rembrandt probably never attended. Instead, his parents agreed to support his training as a painter.

Growing up in a Golden Age

The world which shaped Rembrandt was that of the newly created Dutch Republic, which occupied a small slice of the North Sea coastline of the Low Countries. Much of its territory was below sea level: over the centuries, the land had been skilfully reclaimed from salt marsh, cultivated and built on. By the seventeenth century, the region was transforming into the wealthiest nation Europe had ever known.

This prosperity was rooted in earlier religious, political and economic transformations. The Low Countries had long been ruled by the Holy Roman Emperors of the Habsburg dynasty in far-off Vienna. When, in 1516, the Habsburgs also inherited the throne of Spain, the governance of the region was transferred to Spain. But the northern provinces of the Low Countries had at the same time become predominantly Protestant, and their new Spanish overlords were inflexibly Catholic. In 1579 these northern provinces declared their independence, and eighty years of war followed. By the time Rembrandt was born, the war was in its third decade. Eventually, though, the Habsburgs were defeated, as economic might and the most powerful merchant navy in Europe now belonged to the new Dutch Republic.

The republic was a centre for ship-building and had a long-standing trade in staples such as corn and timber. But when the United East India Company was set up, in 1602, the republic's economic reach went global. The United West India Company followed in 1621, and Dutch colonies were set up on the island of Java, in the Caribbean and on the east coast of America. New Amsterdam – present-day New York – was founded in 1626. These companies imported and exported all manner of goods, including spices, silks, porcelain and tulips, and were actively involved in slavery. In the words of Sir William Temple, English ambassador to the republic between 1668 and 1679, 'no Countrey can be found either in this present Age, or upon Record of any Story, Where so vast a Trade has been managed.'

Not surprisingly, these changes had a dramatic impact on the art produced in the republic: still-life paintings showing piled-up produce from around the world, portraits of wealthy and increasingly powerful merchants, seascapes and landscapes all became popular. Travellers also commented on the beauty, orderliness and cleanliness of Dutch cities.

Learning to paint with passion

Backed by his parents, Rembrandt began his training in art with Jacob van Swanenburgh (1571–1638), a local painter of portraits, architectural scenes and fantastical landscapes who had lived and worked for many years in Italy, then acknowledged to be the centre of the art world. For three years Rembrandt learned the fundamentals of his craft from van Swanenburgh, but the latter's style had no lasting impact on the young painter.

Then, for just six months in 1624, Rembrandt was apprenticed to Pieter Lastman (1583–1633) in Amsterdam. Lastman, a famous history painter, had also studied in Italy. There, he had discovered the art of Caravaggio, which combined the close observation of physical and emotional detail with dramatic composition and abrupt shifts between light and dark. Lastman transmitted his enthusiasm for Caravaggio to his young apprentice, and these dynamic features would typify Rembrandt's works throughout his life, becoming more and more subtle.

An early painting by Rembrandt, *Balaam and the Ass* of 1626, was modelled on a work by Lastman, and was perhaps a tribute to him. The subject is a biblical tale in which a donkey attempts to warn his unseeing master, the priest Balaam, of an angel sent to obstruct his journey to a hostile land. Balaam beats the donkey for stubbornness until the poor animal miraculously speaks and the truth is revealed. Rembrandt's version displays his ability to convey an exciting story within the constraints of a single painted scene – what the film director Peter Greenaway has described as his 'cinematic' image-making.

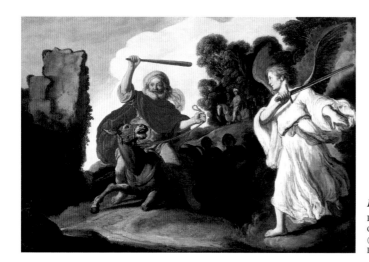

Balaam and the Ass
Pieter Lastman, 1622
Oil on panel, 40.3 × 59.4 cm
(15⅞ × 23⅜ in)
Private Collection, London

Two prodigies

In 1625, after his short apprenticeship with Lastman, Rembrandt returned to Leiden and set up independently in a studio with another local painter, Jan Lievens. Rembrandt was probably living once again with his parents – many of his works from this period depict family members – and since most seventeenth-century Dutch painters had their studios at home, this may have been where both young men worked.

Lievens was a year younger than Rembrandt and had also been trained by Lastman. The two youths quickly drew attention to themselves for the extraordinary skill they had acquired at such a young age. Indeed, according to Orlers' guidebook, Lievens had been famous in Leiden from the age of 12. They appear to have worked well together, supporting each other artistically and sharing the same life models; works by the two artists from this early period have sometimes been confused. In 1628 Rembrandt also took on several pupils, including the young Gerrit Dou, then aged 15, and the lesser known Isaac de Jouderville. Both studied with him until 1631 and paid very well for this training – around 100 guilders a year. Dou would become famous, but not for anything obviously in his teacher's style: he executed exquisitely polished scenes of everyday life, and was a founder of the Leiden school of *fijnschilders* or 'fine' painters.

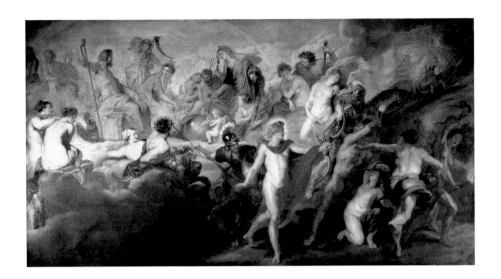

For the love of Rubens

In the 1620s and 1630s, as we have seen, when Rembrandt was starting his career, new types of painting were becoming popular: still lifes, representations of the new merchant classes, land- and seascapes, and genre scenes of everyday domestic life. The earthy, animated portraits of ordinary people by Frans Hals (c. 1582–1666) were among the best loved. But the artist of greatest note from the Low Countries at this time was Peter Paul Rubens (1577–1640) from Antwerp in the southern provinces, which were still under Habsburg control.

Although Rembrandt knew what it was to be admired, even as a young painter, he wasn't above admiring others. Throughout his life he was in awe of Rubens. For a long time he even sought to emulate him in certain ways, for Rubens was famed not only for his artistic talent but also for his wealth, social prestige, worldly influence as a diplomat and business acumen. As a feted artist he had made the most of the opportunities available to him, not only completing impressive commissions for Europe's crowned heads but also establishing a large workshop in Antwerp – really a factory – from where he and his assistants produced thousands of paintings for sale on the open market. In common with Rembrandt's own teachers, Rubens – for whom the Venetian colourist Titian was a great role model – had lived and worked in Italy for many years.

Already unconventional

In the 1620s and 1630s, Rembrandt seems to have painted primarily scenes from history and the Bible. Despite the enormous popularity and commercial success of still life and genre scenes, many art lovers still felt that great artists should produce idealized paintings of heroic acts from history, the Bible or classical mythology. Despite the preference for Dutch Protestant churches to be unadorned, religious works were still in demand in secular settings, often in the home, as a focus for private devotion.

Rembrandt also became well known at this point for creating etchings, including cleverly observed street scenes showing aspects of everyday urban life. An unusual painting to emerge from this period is *An Artist in His Studio*, which seems to represent Rembrandt himself at work. Here, the artist – padded out in a huge robe and wearing a hat, probably to keep warm – is placed in the background of the painting, to the left. The painting's focus is a large canvas with its back to the viewer. The artist is either contemplating what is on the canvas or, possibly, conceiving in his mind what he will go on to paint.

Here, then, is an early example of a theme to which Rembrandt would refer many times – the artist at work. Other seventeenth-century painters would also depict this subject, including Diego Velázquez in his *Las Meninas* of 1656 and Jan Vermeer in the 1660s with *The Art of Painting*. But Rembrandt's interest seems to be in artistic creation as a solitary and introspective activity.

Also of note is the large grindstone positioned against the wall next to the artist, and the table behind him, on which several large glass bottles are visible. Usually it was the job of an apprentice to prepare paint pigments, but during the late 1620s, both Rembrandt and Lievens experimented a great deal with the grinding, mixing and application of pigments, binding and drying agents, varnishes and glazes. Although Rembrandt's brushwork at this stage was relatively smooth, it was nevertheless richly differentiated and thus able to convey a wide range of surface textures.

A prestigious patron

By the time Rembrandt started taking on his own students, in 1628, his fame and that of Lievens had shot to such heights that the two boys from Leiden finally attracted the attention of the republic's great and good. Constantijn Huygens was personal secretary to Prince Frederick Henry of Orange, the new stadtholder (head of state) – although the republic was not a kingdom, it still had an aristocracy, and the princes of Orange ranked at its very top. The stadtholder was a servant of the republic and exercised limited powers, but his standing and influence were great. Huygens' service to the stadtholder included commissioning and purchasing prestigious works of art for the stadtholder's collection. Cultivated and sophisticated, Huygens, who had studied law at the University of Leiden, was well suited to this role as the prince's right-hand man. Ten years older than Rembrandt and Lievens, he was also a much admired poet, a speaker of many languages, an accomplished musician, a painter of miniatures and a well-travelled diplomat for the republic. In 1622, he had received a knighthood from King James I of England; he could count among his friends the English natural philosopher Sir Francis Bacon and had translated poems by John Donne into Dutch.

Constantly on the lookout for artistic talent, Huygens was initially drawn back to Leiden by the reputation of Jan Lievens. He naturally became acquainted with Rembrandt's work too, remarking in his autobiography of 1631 on Rembrandt's 'superior elegance of touch' and his ability 'to communicate intense emotion in his work'.

Huygens became a great supporter and mentor of the two young artists. He encouraged Rembrandt, for instance, to keep focusing on religious and mythological themes. For Huygens too, Rubens was the ideal to aspire to (what a pity that the Antwerp-based artist was in the employ of the Habsburg enemy!). Huygens also tried, in vain, to persuade both young men to travel to Italy to perfect their art. But he was convinced that they were already the equals of the most famous painters of the day, and would soon surpass them. Of the several works by Rembrandt that Huygens purchased on behalf of the prince, some were given as diplomatic gifts to the English crown and remain in the British Royal Collection.

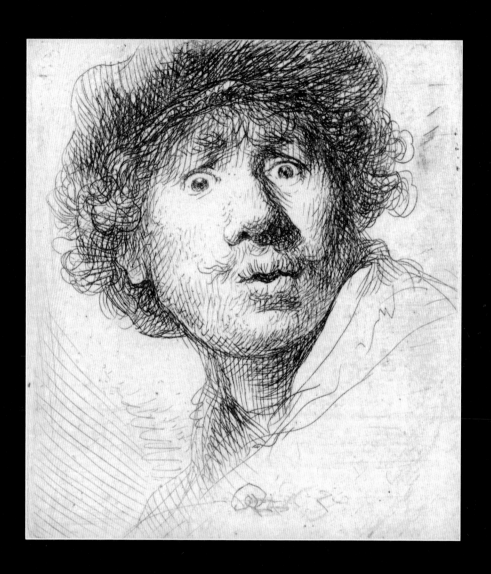

Self-Portrait with Wide-Open Eyes
Rembrandt, 1630

Etching, 5.1 × 4.5 cm (2 × 1¼ in)
Rijksmuseum, Amsterdam

The emotive self-portrait

> 'Almost singlehanded, Rembrandt established the self-portrait as a central mode for painters and as a major type of western painting.' *Svetlana Alpers*

One reason for Rembrandt's ability to express intense emotion in his work was endless hours of practice, often using himself as a model. Indeed, many of the early self-portraits were what were known as *tronies* – images of faces approached from a psychological perspective and depicting a range of characters and passions. Rembrandt would sit in front of a mirror and, like an actor, adopt different facial expressions, at once seeing and feeling them. A lifelong fan of the theatre, he also collected exotic costumes and props, mixing observation with imagination in producing his work. Rembrandt had first developed his taste for the dramatic under Lastman, and years of using himself as a model resulted in a prodigious skill at portraying faces. In addition to paintings, there are numerous drawings and etchings by Rembrandt of his own face. His *Self-Portrait with Wide-Open Eyes* from 1630 is extraordinary not only for its fluent and lively line, but also because Rembrandt achieved all that on such a miniature scale – the face is barely larger than a postage stamp.

A death and a new beginning

Rembrandt used not only himself but also his family as models for his portraiture studies. One of the last portraits he made of his miller father was an exquisitely detailed image in red and black chalk against a rough, gestural background. Harman Gerritsz. van Rijn died on 27 April 1630, so this must have been made just months, or even days, before his death.

Lievens and Rembrandt had also reached a point where they had outgrown Leiden and perhaps each other. In 1631 Lievens departed for England to work for the court and other prestigious patrons. Later in the decade, he would move on to Antwerp, where he would finally meet their great idol Rubens (and end up adopting his style completely). Rembrandt decided to move to Amsterdam, although it did mean leaving behind his widowed mother and siblings. By late 1631, at the age of 25, he was settled in that great city and, with the exception of a few journeys within the republic, he would stay there for the rest of his life. Some scholars have wondered whether Rembrandt *did* travel further afield – to England, for instance, on the basis of several etched scenes by him of English cityscapes, including one dated 1640 of London's Old St Paul's Cathedral. But these were almost certainly just copies of topographical prints; scenes of Turkish ruins by Rembrandt also exist, and it is certain that he did not travel to the Ottoman Empire.

HARMAN. GERRITS.
van Rijn

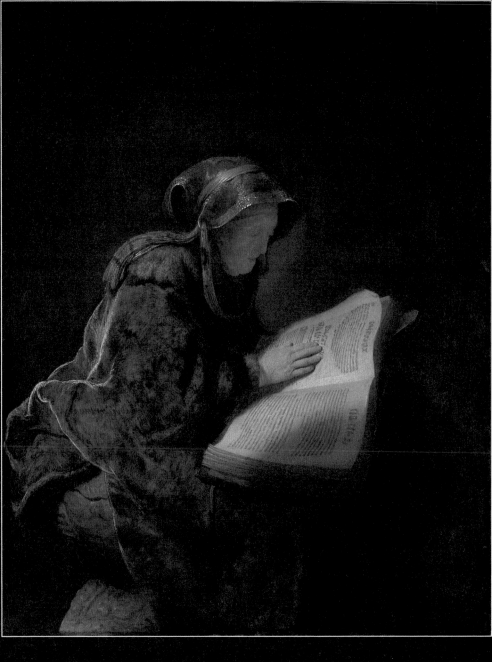

An Old Woman Reading,
Probably the Prophetess Hannah
Rembrandt, 1631
Oil on panel, 60 × 48 cm (23⅝ × 18⅞ in)
Rijksmuseum, Amsterdam

A memento of his mother?

Shortly before leaving Leiden, Rembrandt also painted this moving study of an elderly woman reading. His mother, Neeltgen, is quite likely to have been the model.

Rembrandt excelled in such works, known as *portraits historiés*, where sitters would be depicted in the guise of historical or biblical characters. It appealed to his strength in emotive portraits and his love of the drama of the theatre. In this portrait he represented his mother – if it is indeed she – as the prophetess Hannah, or Anna, famous for her devotion to fervent prayer, worship and fasting day and night. Rembrandt admired his mother's own down-to-earth religious devotion, and a portrait such as this would be a fitting tribute to her. Neeltgen was possibly a Protestant, like her husband and Rembrandt himself. However, she came from a staunchly Catholic family. Although Calvinism was the official religion of the republic, and the Dutch Reformed Church the official church, about a third of the population, including many from the upper classes, had remained Catholics. Although unable to worship publicly, in the republic's atmosphere of religious tolerance they were generally left in peace to practise their faith privately.

An enduring aspect of Rembrandt's biblical paintings is that they never moralize. Instead they probe the psychology of the situation – the internal changes that are wrought through a deep engagement with belief. This painting, though, also explores another theme, common to Dutch painting of the day: people engaging with the latest in information technology, namely reading the printed word. Here again we find Rembrandt's trademark psychological depth. He has depicted the old woman not so much reading as tenderly drawing her fingers over the luminous pages of the huge, heavy book over which she bends. Her face, although glowing in reflected light, is nonetheless in relative shadow compared to her hand (which Rembrandt emphasizes), as if to suggest that she is nearly blind. Indeed, throughout his life Rembrandt would depict with astonishing sensitivity not only women of all ages and backgrounds but also anyone or anything that was old and vulnerable. This was the opposite of the direction art in the rest of Europe was taking; there the emphasis in painting was increasingly on the idealized and majestic.

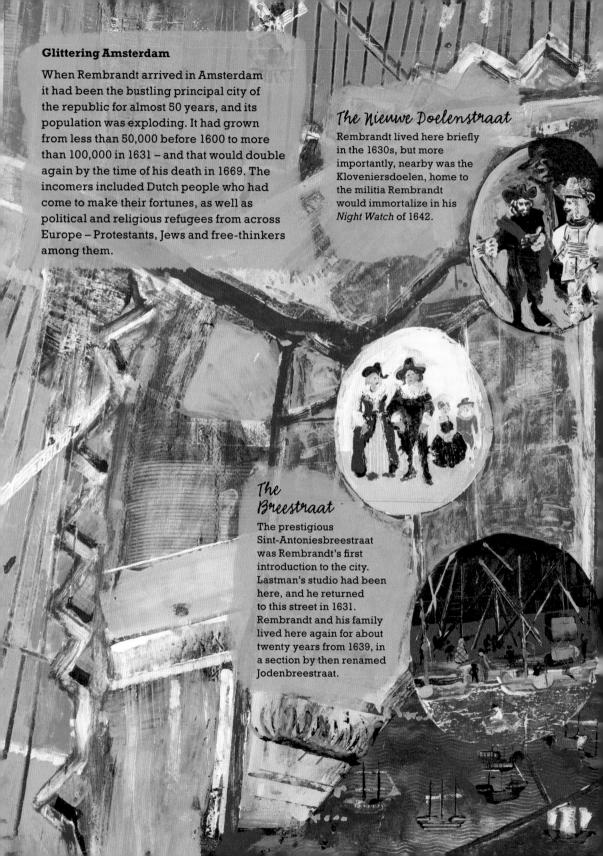

Glittering Amsterdam

When Rembrandt arrived in Amsterdam it had been the bustling principal city of the republic for almost 50 years, and its population was exploding. It had grown from less than 50,000 before 1600 to more than 100,000 in 1631 – and that would double again by the time of his death in 1669. The incomers included Dutch people who had come to make their fortunes, as well as political and religious refugees from across Europe – Protestants, Jews and free-thinkers among them.

The Nieuwe Doelenstraat

Rembrandt lived here briefly in the 1630s, but more importantly, nearby was the Kloveniersdoelen, home to the militia Rembrandt would immortalize in his *Night Watch* of 1642.

The Breestraat

The prestigious Sint-Antoniesbreestraat was Rembrandt's first introduction to the city. Lastman's studio had been here, and he returned to this street in 1631. Rembrandt and his family lived here again for about twenty years from 1639, in a section by then renamed Jodenbreestraat.

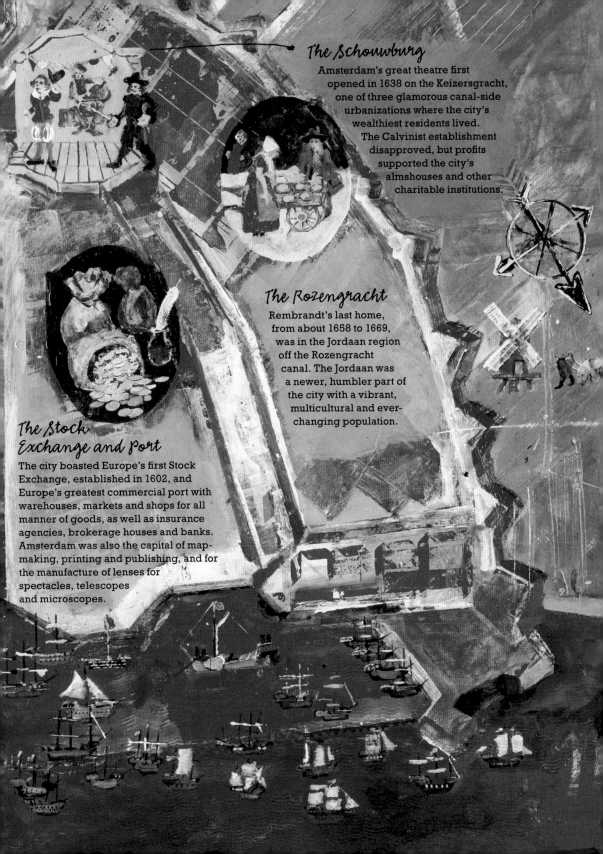

The Schouwburg

Amsterdam's great theatre first opened in 1638 on the Keizersgracht, one of three glamorous canal-side urbanizations where the city's wealthiest residents lived. The Calvinist establishment disapproved, but profits supported the city's almshouses and other charitable institutions.

The Rozengracht

Rembrandt's last home, from about 1658 to 1669, was in the Jordaan region off the Rozengracht canal. The Jordaan was a newer, humbler part of the city with a vibrant, multicultural and ever-changing population.

The Stock Exchange and Port

The city boasted Europe's first Stock Exchange, established in 1602, and Europe's greatest commercial port with warehouses, markets and shops for all manner of goods, as well as insurance agencies, brokerage houses and banks. Amsterdam was also the capital of map-making, printing and publishing, and for the manufacture of lenses for spectacles, telescopes and microscopes.

Rembrandt lands on his feet

Rembrandt couldn't have had a better start in Amsterdam. His first accommodation in the city was in the house of Hendrick van Uylenburgh, an art dealer and entrepreneur with an international clientele. Van Uylenburgh's home was on the prestigious Sint-Antoniesbreestraat. In his gallery and workshop portraits were produced, works of art restored and imported paintings from Italy and Germany displayed. Here Rembrandt worked alongside other painters and took on apprentices and students.

The relationship between the two men seems to have begun in 1631 while Rembrandt was still in Leiden. Reaping the benefits of his success in that city, Rembrandt invested a substantial amount of money – 1,000 guilders – in van Uylenburgh's business. The art trade was a lucrative one in the republic – since there was not a lot of land to invest in, everyone invested in pictures. And unlike in the rest of Europe, people from all classes purchased and commissioned art. Van Uylenburgh was evidently impressed by Rembrandt's ambition as well as his talent.

At van Uylenburgh's, Rembrandt quickly received numerous commissions to paint portraits of the city's wealthy patricians and merchants, many of whom were van Uylenburgh's clients or were impressed by Huygens' patronage of him.

Rembrandt's portraits may have been in such demand because he successfully catered for two apparently contradictory desires. On the one hand, his clients wanted to show off their wealth. On the other hand, whatever their religious or social background, most also wanted to convey the values of restraint, humility and common sense that were so important within Calvinism. So at first glance these are sober men and women dressed in black, but a closer look reveals extraordinary opulence woven into the fabric and detailing of their garments. Rembrandt had a well-deserved reputation for being able to convey all kinds of material and surface qualities with an almost magical ease and precision. He would also encourage his clients to embellish their costume with exotic items that either he or van Uylenburgh had purchased for the purpose, such as an extravagant piece of headgear, over-the-top lace or a cape or pantaloons seemingly of cloth-of-gold.

A startling group portrait

In 1632, a year after arriving in Amsterdam, Rembrandt created
one of his best-known group portraits. It shows the famous
surgeon Dr Nicolaes Tulp performing an autopsy, with seven
enraptured city officials looking on, crowded around the corpse.
Such dissections were usually held during the winter months,
when the cadavers that were opened up – always executed
male criminals – would last several days. In a culture that liked
to be seen as encouraging scientific enquiry, these gruesome
procedures were treated as (admittedly sensational) educational
events, for which tickets were sold. With his left hand, Tulp
demonstrates the motions the dead man's exposed tendons would
have caused his hand, if living, to make. The cadaver, incidentally,
was that of one Adriaan Adriaansz. of Leiden, also known as Aris
Kindt, executed for robbery with violence.

Given the painting's detail, Rembrandt would have had to be
present at the dissection. However, for the sake of decorum he
obviously also practised a bit of artistic licence. In actuality,
arms and legs would have been the last, not the first part of the
body to be dissected, since they were slower to decompose; in
truth, we should be looking at Adriaan totally sliced and diced.

As for artistic inspiration, Rembrandt had drawn on Rubens'
The Tribute Money of 1612, in which Christ disputes with the
priests of the temple who attempt to entrap him. In Rembrandt's
composition Tulp replaces the figure of Christ, while the city
officials replace the devious priests. Another feature of the painting
is Rembrandt's signature. From 1632 he began to sign himself
just with his first name (here we read 'Rembrandt *fecit*' – made
by Rembrandt) in the manner of the great Italian masters of the
previous century, Leonardo, Michelangelo, Raphael and Titian.

The Tribute Money (detail)
Peter Paul Rubens, c. 1612
Oil on panel, 144.1 × 189.9 cm
(56¾ × 74¾ in)
The Fine Arts Museums of San
Francisco, museum purchase,
M.H. de Young Art Trust Fund,
44.11

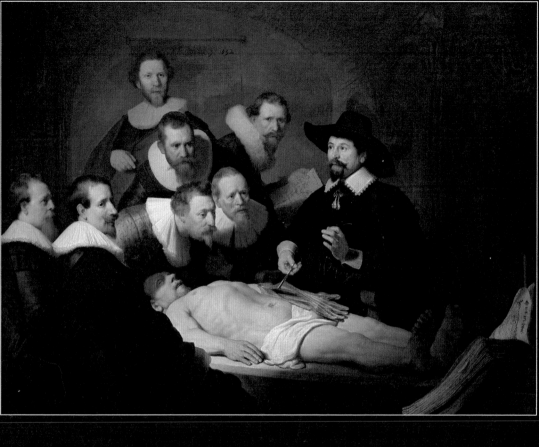

The Anatomy Lesson of Dr Nicolaes Tulp
Rembrandt, 1632
Oil on canvas, 169.5 × 216.5 cm (66⅜ × 85¼ in)
Mauritshuis, The Hague

Making an impact

Throughout the 1630s Rembrandt's fame continued to grow. In 1632 he painted Amalia van Solms, the wife of the stadtholder, Frederick Henry. Frederick Henry also commissioned a series of five large paintings on the theme of the Passion of Christ, probably intended for the Noordeinde Palace in the republic's official capital, The Hague. This would take Rembrandt most of the 1630s to complete.

Rembrandt did not rely only on Huygens' patronage or van Uylenburgh's clients. He made friends and acquaintances throughout the professional and cultural spheres of the city. Many, like Dr Tulp, were in the medical profession; at the time there were between 50 and 60 doctors practising in the city. Rembrandt also had connections with members of the many different religious groups who sheltered in the city, such as the Portuguese Jewish writer Menasseh ben Israel, who was also the republic's first Hebraic printer as well as being a mentor of the great philosopher Baruch Spinoza.

Several of these acquaintances became clients. Indeed, Rembrandt seems to have been a man of very cosmopolitan inclination in what was then one of the most cosmopolitan cities in the world. Through such connections he consolidated his position as the in-demand painter.

guild membership

a lively social circle

prestige in high places (The Hague)

Rembrandt's initial investment of 1,000 guilders into the business of selling art must have paid off because he continued to act as a kind of agent for his own work and that of other painters. Nonetheless, according to an admittedly less-than-sympathetic eighteenth-century biographer, Arnold Houbraken, Rembrandt may sometimes have been rather recalcitrant where clients were concerned. In Houbraken's words, 'one must beg him and still add money.'

In 1634, a mere three years after arriving in the city and a record year in terms of his output, Rembrandt obtained important professional recognition by being accepted as a member of the painters' Guild of St Luke. This permitted him to increase his income and reputation even further by again taking on pupils and apprentices. During the 1630s the future Dutch Old Masters Ferdinand Bol and Govaert Flinck would be among their number.

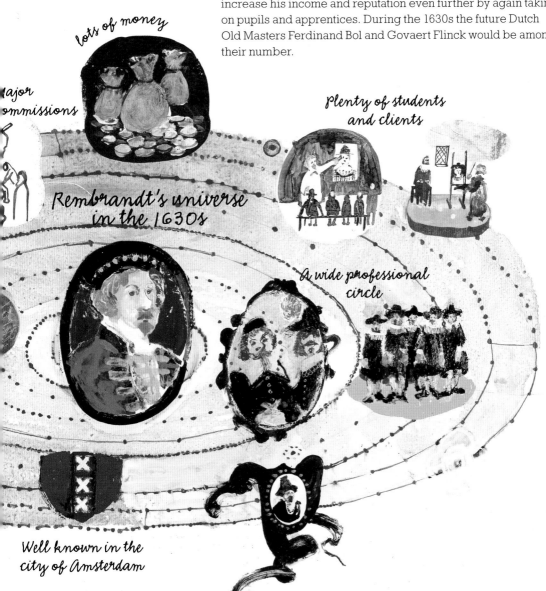

lots of money

Major commissions

Plenty of students and clients

Rembrandt's universe in the 1630s

A wide professional circle

Well known in the city of Amsterdam

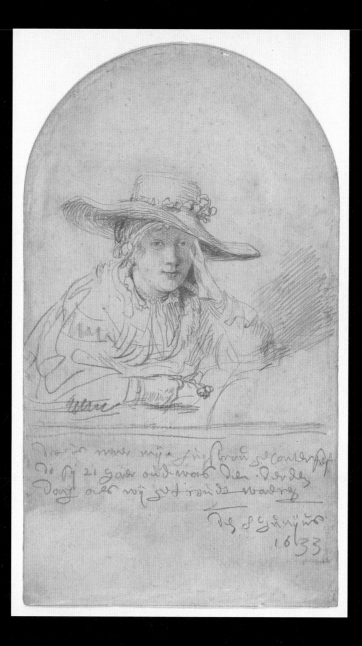

Saskia with a Straw Hat

Rembrandt, 1633

Silverpoint on white prepared vellum,
18.5 × 10.7 cm (7¼ × 4¼ in)
Kupferstichkabinett, Staatliche Museen zu Berlin,
Inv. KdZ 1152

The lovely Saskia

But 1634 wasn't only a landmark year professionally. On 2 July Rembrandt married Saskia van Uylenburgh, Hendrick's niece.

Saskia was the youngest daughter of a wealthy patrician and one-time burgomaster (or mayor) of Leeuwarden, a city in the republic's northern province of Friesland. Orphaned at the age of 12, she had been raised in her eldest sister's family before moving to Amsterdam as a young woman to live with her uncle. She was probably just 20 years old when she and Rembrandt met and fell in love.

In 1633 Rembrandt made a beautiful drawing as a testament to their engagement. The handwritten text underneath the image reads: 'This is drawn after my wife, when she was twenty-one years old, the third day after we were betrothed – 8 June 1633.' Saskia is shown gazing at her lover, her expression delicate and difficult to read: seemingly contemplative and self-contained yet also tenderly, perhaps even amusedly observant. By drawing her in a simple straw hat with flowers, Rembrandt was referencing a popular look for women at the time (first made fashionable in Italy in the previous century), based on pastoral themes and the figure of the shepherdess.

Saskia brought with her the van Uylenburghs' considerable wealth and high status. By marrying her, Rembrandt was definitely marrying up. Her dowry was probably 20,000 guilders, but may have been as much as 40,000. Perhaps for this reason, and despite Rembrandt's already well-established reputation as a successful artist, there was some hesitation regarding the match on the part of Saskia's guardian, and also, it seems, on the part of Rembrandt's mother. But marry they did, and the wedding took place in Saskia's native Friesland, perhaps to appease her remaining relatives.

The marriage would be very happy. Rembrandt and Saskia loved each other and seem to have had a good deal of fun together. But their lives would nonetheless be beset by sorrow. Three of their four children would die as babies. By the winter of the following year, 1635, the first of these infants was born: Rumbertus. He was baptized ten days before Christmas but died a few months later. Plague had broken out in the city. It would kill one in five of the population that year, and Rumbertus was probably one of its tiny victims.

A compulsive collector

By the age of 29, Rembrandt was a wealthy man. In 1635, a year after the wedding, he and Saskia left van Uylenburgh's home and rented an elegant house to the south of the city, on the Nieuwe Doelenstraat, overlooking the river Amstel. In 1637 they would move again to a grander house in another fashionable neighbourhood, and in 1639 they would move to the grandest house of all, on the Jodenbreestraat (now the Rembrandt House Museum), near Saskia's uncle. Because Rembrandt had so many pupils, between 1637 and 1645 he appears to have rented a large disused warehouse on the Bloemgracht, which he converted into studios. During this period Rembrandt also visited a good many auctions and sales as part of his own art-dealing business. And, like many of his well-off peers in the city, he established a wide-ranging personal collection: art, curiosities from around the world, objects of historical and scientific interest, weapons, plants, stuffed animals and more – including erotic art (Rembrandt was no saint). He and Saskia also kept several pets: dogs, and a 'filthy' but much-loved monkey.

Hendrick van Uylenburgh reputedly had a motto: 'In restraint lies strength.' But neither Rembrandt nor Saskia was heeding it. Rembrandt would remain for the rest of his life obsessive and extreme where the purchase of art and artefacts was concerned, and it was this compulsion that would play the largest part in his later financial collapse. He may also have become involved in various kinds of speculation in the republic's newly established stock market. The most famous speculation in the republic at this period was the one surrounding tulips – the so-called tulip mania. In 1636 it was at its peak, with a single bulb fetching prices ten times higher than a craftsman's annual wage. When the market for tulips subsequently crashed it ruined many an unwise and unwary speculator, and tulip mania has become a byword for any commodity whose market value far outstrips its intrinsic value. We do not know whether or not Rembrandt got caught up in this particular folly, but it does demonstrate that he and Saskia were not the only people in the city to be spending unwisely.

A prodigal life

In 1638 tensions erupted when Saskia's relatives accused her of squandering her inheritance in a 'flaunting and ostentatious' manner. Rembrandt vigorously denied it, and even initiated a slander action against them. According to the records, his defence was that he and his wife 'were richly and superabundantly endowed' and thus too wealthy to be accused of such a charge. He ended up losing the action. Interestingly, though, in a painting created at the beginning of their marriage, Rembrandt had cast himself and Saskia in just such a profligate role. He painted himself as 'the prodigal son' of biblical fame, who, having demanded that his father give him his share of the family inheritance, wasted it all in riotous living. Here, Rembrandt-as-Prodigal is in a tavern drinking and whoring. Saskia is the prostitute sitting on his lap. They are indulging in the pleasures of life, although Saskia looks a lot less carried away than her husband does. The nineteenth-century English art critic John Ruskin loved this painting, despite not being entirely enamoured of Rembrandt's work in general. Ruskin described the work as, 'his greatest picture, so far as I have seen', for it depicted what Ruskin felt was 'a state of ideal happiness'.

The year of the slander case also witnessed the birth, baptism and death of their second child, a daughter, Cornelia, who was named after Rembrandt's mother.

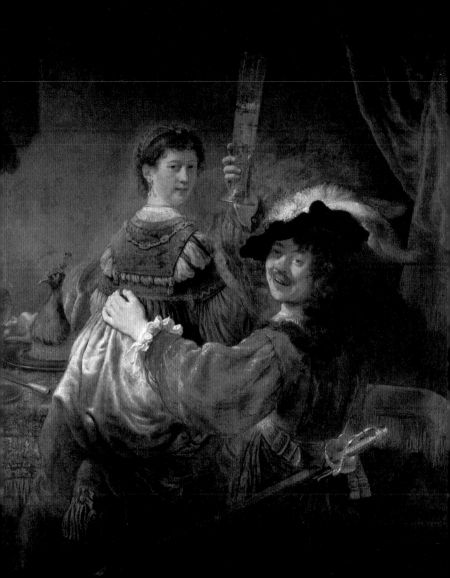

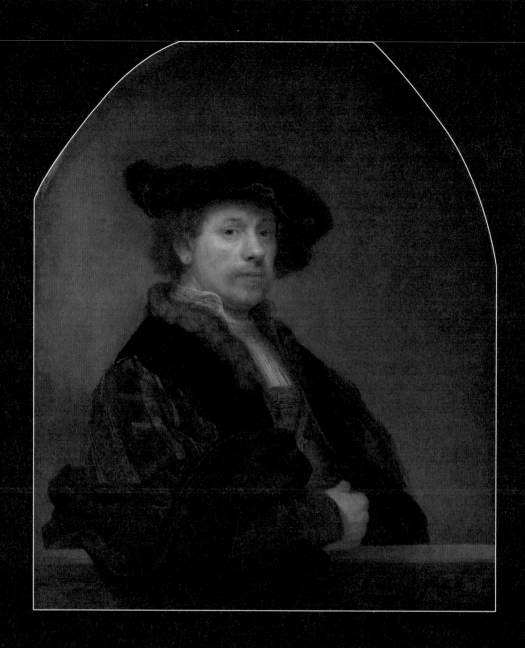

Self-Portrait

Rembrandt, 1640

Oil on canvas, 102 × 80 cm (40⅛ × 31½ in)
National Gallery, London

Pride before a fall

In material terms, 1639 was a high point in Rembrandt's life. At the beginning of the year he bought the impressive new house on the Jodenbreestraat. It was a so-called double house and had recently been remodelled and enlarged – possibly by the most famous Dutch architect of the era, Jacob van Campen, who had also just built the Schouwburg theatre. The house also contained ample studio and teaching space. But at the then exorbitant price of 13,000 guilders, it was no bargain. Rembrandt's intention was to pay off this sum, plus interest, in instalments within five years. These payments were to be made to the seller, one Christoffel Thijs, who held the mortgage. The family moved in on 1 May 1639, the first of May being the conventional date for house moves to take place.

A year later, at the age of 34, Rembrandt painted a self-portrait that reinforces his sense of having arrived. The pose he adopted was modelled on a great work by the Venetian painter Titian, thought by many scholars to be a self-portrait. Rembrandt would have known the original painting, since it was owned by an acquaintance, the wealthy Spanish Jewish diamond and art dealer Alfonso Lopez, who had also purchased Rembrandt's early work, *Balaam and the Ass* (see page 11).

But all was not entirely well. In 1639 Rembrandt had finally completed the Passion cycle commission for Prince Frederick Henry, but a dispute over pay had arisen with Huygens as the prince's agent. Rembrandt had requested an increase, which was refused, and then payment was delayed. When he was paid eventually on 17 February 1640, the sum was considerably smaller than he had hoped. As far as Huygens was concerned the relationship was over. He never again recommended Rembrandt for important commissions.

A tough teacher

According to the seventeenth-century writer and painter Joachim von Sandrart, Rembrandt's house 'was crowded with almost innumerable young men who came for instruction and teaching'. Rembrandt was a dedicated and demanding teacher. During his lifetime he appears to have had over 50 students or apprentices, many of whom went on to fame and fortune themselves.

As part of the learning process, many of them produced 'Rembrandt-style' paintings and indeed (certified) copies of his work that were marketed to the public. This was normal practice at the time. But for this reason several paintings long thought to have been by Rembrandt have been reassessed in recent years – by carefully analyzing the painting techniques used or by studying their substructures with the aid of scientific and technical tests – and reattributed to unknown students or followers.

Rembrandt's students worked in a large attic workshop. His own studio, as well as the gallery holding his collection, was on the floor below. Rembrandt probably also still housed students in the Bloemgracht warehouse.

Rembrandt mainly taught from life models and also – since the emphasis of his workshop was on history and biblical painting – by getting his students to act out scenes and then draw them. According to one anecdote, students sometimes took things too far. One student decided that he would paint his nude model while in a state of similar undress. Both were unceremoniously thrown out by Rembrandt.

Several drawings also exist that show corrections made by Rembrandt for the purposes of instruction. According to Houbraken, the well-known Samuel van Hoogstraten, one of Rembrandt's students during the early 1640s, reported being reduced to tears of frustration as he tried to meet his master's standards.

Death closes in

Rembrandt had success and status, but this continued to be intertwined with sorrow. In the summer of 1640 Saskia gave birth for the third time: another daughter, again named Cornelia. She was baptized on 29 July, but she too died a short time afterwards. Although high levels of infant mortality were common at the time, that surely made the deaths no easier to accept. Then, at the end of 1640, Rembrandt's mother died. The records show that her total estate came to the not insubstantial amount of 9,960 guilders, mostly invested in property and some in the form of loans (banking was still in its infancy, so individuals habitually lent to and borrowed from one another). How the estate was shared out among her many surviving children is unknown. Nevertheless, it is unlikely to have been able to resolve any of Rembrandt's growing money problems.

Nearly a year later Saskia finally gave birth to a child who would survive: their son Titus. He was named after Saskia's favourite sister, Titia, and commemorated another loss: Titia, a frequent visitor to the van Rijn household, had died some months earlier. Titus was baptized on 22 September 1641 in the nearby Zuiderkerk.

Mourning Saskia

Tragically, on 14 June 1642 Saskia died – not a year after Titus was born. She was not yet 30, and Rembrandt at 36 was a widower. Saskia's resting place – which today is commemorated with a plaque – was in Amsterdam's prestigious Oude Kerk, the oldest known building in Amsterdam, dating from about 1213. In her will, Saskia made conditions that would have a long-lasting impact on Rembrandt's future: half of her fortune would go to Titus and half to Rembrandt, but on the condition that he did not remarry.

By all accounts, Saskia and Rembrandt had enjoyed a happy marriage; we cannot imagine what the loss of this young woman must have meant to him. He had made many portraits of her, and while several showed her in her prime, many later drawings, equally exquisite, show her lying in bed sleeping, resting or perhaps ill, her face looking drawn and tired.

Despite the loss and sorrow of the early 1640s Rembrandt continued to paint and to teach. He also created the work for which he is best known: the now world-famous *Night Watch* of 1642, completed just months before Saskia's death.

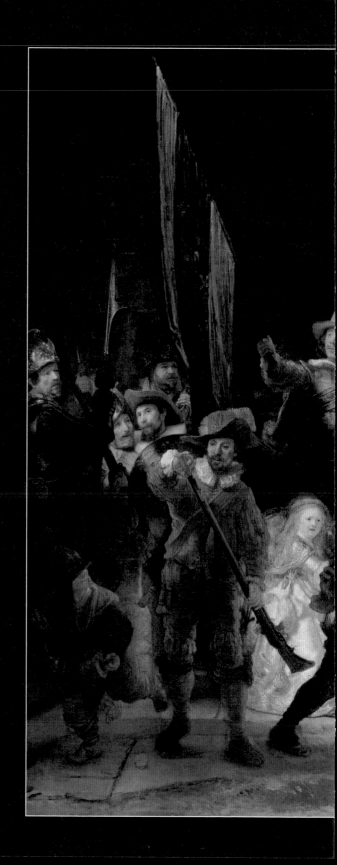

The Night Watch
Rembrandt, 1642

Oil on canvas,
379.5 × 453.5 cm (149⅜ × 178½ in)
Rijksmuseum, Amsterdam

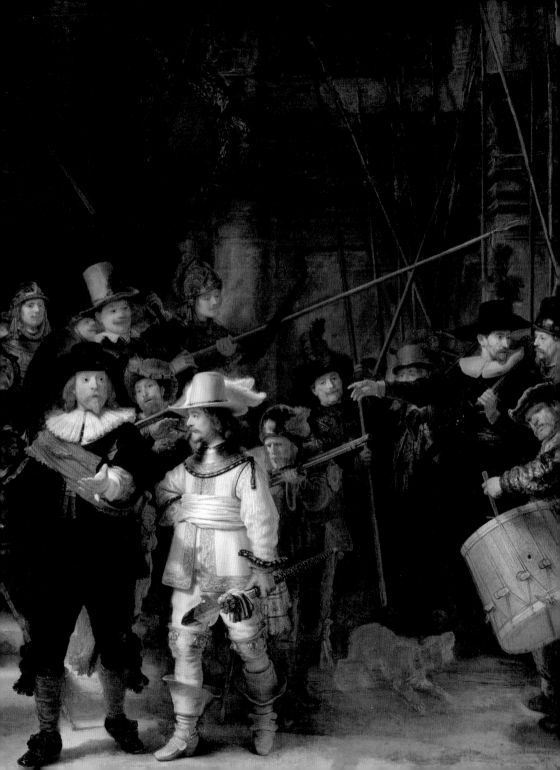

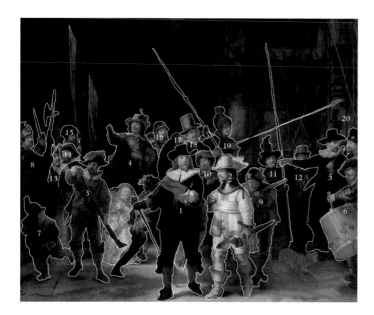

'So painterly in thought, so dashing in arrangement, and so powerful.' *Samuel van Hoogstraten*

This monumental painting was not in fact intended to be a night scene; it has simply darkened over time. It is a group portrait of one of the militia companies that helped to maintain order within the city. These companies were made up of prominent Amsterdammers – in this case merchants involved in the textile trade – and had been established to support the powerful regents who administered the city, and to protect both freedom and property.

Although most of the individuals portrayed in the painting are now unknown, each person whose face is clearly visible would have paid Rembrandt approximately 100 guilders for the privilege. Others would have paid smaller amounts proportionate to their prominence in the overall composition.

The most important figure, centrally positioned in black with a red sash, is Captain Frans Banninck Cocq, portrayed giving the signal to move out. Cocq was also a member of the city council, and in the early 1650s would be burgomaster. At his side, in a sumptuous yellow outfit with white sash, is his lieutenant, Willem van Ruytenburgh. His bright costume provides the backdrop upon which the shadow of Cocq's outstretched hand is cast. Also prominent is the ensign, Jan Visscher Cornelissen, who carries the company's colours.

Interpretation

Perhaps the most puzzling portion of the painting is the image of the young girl, also in glowing yellow, incongruously placed in the midst of the men and holding, among other things, a dead chicken. She is taken to be the company's mascot. It has been pointed out that this girl has something of the look of Saskia.

But the most outstanding characteristic of the painting is that instead of portraying his sitters formally, in an orderly row, as was the norm – Frans Hals' and Pieter Codde's slightly earlier painting of a militia company (below) is a case in point – Rembrandt presents them in his own way, in the midst of (probably contrived) lively action as they prepare to go out on a daytime march.

There has been some debate about how this unusual painting was received at the time. This is partly because of a claim attributed to van Hoogstraten, who was at the unveiling, that the painting's highly active, even chaotic appearance was met with bewilderment. Van Hoogstraten asserted that with its focus more on drama than on portraiture, it was 'too much according to Rembrandt's own wishes'. However, there are other indications that it was, in fact, met with approval. Cocq, certainly, had at least one copy made in watercolour, and the work itself went on prominent display in the militia's Kloveniersdoelen building.

The Meagre Company
Frans Hals and Pieter Codde, 1637
Oil on canvas, 209 x 429 cm
(82¼ × 168⅞ in)
Rijksmuseum, Amsterdam

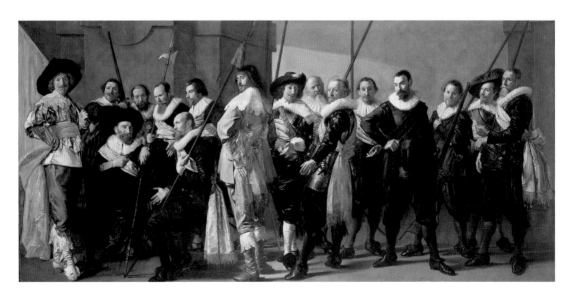

Trouble at home

Following Saskia's death in 1642, Geertge Dircx, described as 'the widow of a trumpeter' and 'a farm woman', joined the van Rijn household as Titus' nursemaid. She was in her early 30s, energetic, robust (in contrast to the delicate Saskia), efficient, and sensible, if uneducated. Rembrandt fell for her. Much to the disapproval of Saskia's uncle and Amsterdam society in general, she lived as Rembrandt's common-law wife for six years. Rembrandt may have lost several well-paying students as a consequence, but he didn't care, giving her expensive jewellery that had belonged to Saskia. In 1647, however, when Titus was 5 or 6 years old, a second, much younger woman arrived on the scene. Hendrickje Stoffels, a pretty army sergeant's daughter, joined the household. She soon became Rembrandt's model and then his lover.

Geertge found out that Rembrandt was having an affair with Hendrickje, and in 1649 she took him to court, claiming breach of promise. Rembrandt and Hendrickje strenuously denied this – after all, hadn't Saskia's will made remarriage financially unviable? The court found in favour of Rembrandt, but decreed that he pay Geertge 200 guilders a year in maintenance costs for life.

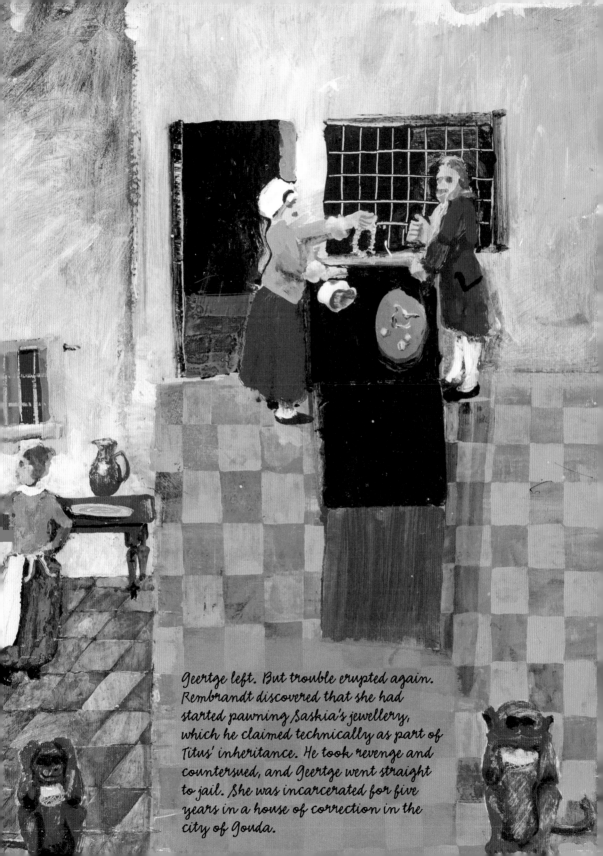

Geertge left. But trouble erupted again. Rembrandt discovered that she had started pawning Saskia's jewellery, which he claimed technically as part of Titus' inheritance. He took revenge and countersued, and Geertge went straight to jail. She was incarcerated for five years in a house of correction in the city of Gouda.

A new inwardness *and* outwardness

Despite all the upset and chaos in Rembrandt's family life, his artistic output doesn't seem to have missed a beat. During the 1640s two inter-related shifts in sensibility occurred in his image-making.

On the one hand, in contrast with the evident theatricality of works like *The Night Watch*, there was an increased simplicity and inwardness, a quietude and a greater sense of intimacy to his compositions. On the other hand, his repertoire of subjects seemed to be expanding. Unlike many other seventeenth-century Dutch artists, who made their mark by specializing in one artistic genre – such as landscapes, portraiture, genre scenes or still lifes – Rembrandt began adding to his mainstay of portraits and biblical and mythological subjects. He turned more emphatically to the surrounding landscape for inspiration, recording it in drawings, prints and paintings. An etching from 1645, *The Omval*, is ostensibly a lively scene of life on the water, just where the Amstel river meets a canal. But in the foreground, and filling the left-hand side of the image, is an enormous, ravaged tree sheltering a pair of almost invisible lovers. Rembrandt's landscapes were mainly drawn or etched. Although the etchings would have been finished in the studio, he probably began them out of doors, observing the landscape using drypoint, a technique in which a sharp tool (a burin) is used to incise an image directly onto a metal etching plate.

Several theories have been put forward as to why Rembrandt now took to wandering the countryside. There is the obvious distraction such walks would have given him from his unsettled home life. And at the time, drawing from life or nature was regarded as a powerful antidote to the melancholia to which artists were conventionally said to be prone. Most of all, though, the new focus on the landscape helped Rembrandt to simplify his visual style. His expansion into the new subject matter of landscape seems to have brought a more subtle and meditative quality to his work overall – a quality that would grow even richer with the passing years.

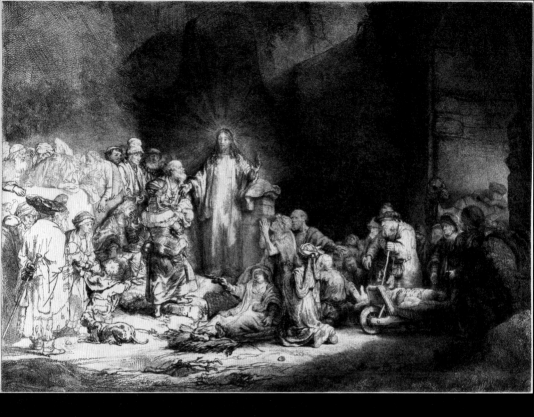

Christ Preaching (Hundred Guilder Print)
Rembrandt, c. 1646–50
Etching, 28.2 × 39.5 cm (11⅛ × 15½ in)
Rijksmuseum, Amsterdam

A famous printmaker

Another area in which Rembrandt expanded his repertoire was in printmaking. In 1642 – and perhaps as early as 1639 – he started work on what would be his best-loved print. It is a biblical image that cleverly compresses into one scene several incidents from St Matthew's Gospel of Jesus teaching, healing and blessing the ordinary people around him, young and old, while his critics, the priests of the temple, look on. Rembrandt worked and reworked the plate over many years, using a wide range of established and new printmaking techniques, and experimenting with various unifying compositional effects.

As with his religious paintings, Rembrandt's religious prints did not have an overtly moralistic message. Instead, they seem deeply personal and meditative, and of course they depict moments when the natural, human and divine intertwine. It is this kind of three-fold seeing and feeling that makes Rembrandt's work so rich and compelling.

Since the early eighteenth century this work has been known as the *Hundred Guilder Print* because of the exorbitantly high price a copy of it supposedly reached at auction. It was rumoured that Rembrandt himself had pushed up the price in order to enhance the work's reputation, and also that of his paintings.

Prints were important commodities during the seventeenth century, including reproductions, usually engravings, of famous paintings. This was probably how Rembrandt had come to know many of the works by his beloved Caravaggio and Rubens. One of Rembrandt's good friends was the print-seller and publisher Clement de Jonghe, who published many prints after Rembrandt's own paintings. At the same time that Rembrandt was working on religious works like the *Hundred Guilder Print*, incidentally, he was also producing etchings on erotic themes.

Many collectors liked to purchase examples of the different 'states' or 'impressions' that specific prints went through, as artists experimented with and reworked their compositions by making adjustments to the printing plate itself; plates could be burnished to remove marks, and of course additional marks and textures could be added. Sometimes collectors even purchased multiple copies of the same state of a print, enjoying the variations that arose from differences in how ink had been applied to the plate, or choice of paper used. Rembrandt was particularly fond of imported Oriental papers.

Jan Six: poet, playwright and friend

During the late 1640s and the 1650s, Rembrandt also used etching to create portraits of important local figures. Among them is an etching from 1647 of the playwright Jan Six. Six and Rembrandt were friends, and had no doubt bonded over their mutual enjoyment of the theatre. Six came from a wealthy family of Protestant Huguenot refugees from France; his father, on arrival in Amsterdam, had set up a business consisting of dye works and silk mills, now run by Six's impressive, business-minded, widowed mother, Anna Wijmer. Six, who was drawn more to art, literature and learning, was well known in the city's intellectual circles, and had connections with the philosophers Spinoza and René Descartes. Six also shared Rembrandt's love of collecting, and he owned many Dutch and Italian paintings as well as *objets d'art*. In this etching, Six – who was 12 years younger than Rembrandt – is reading in front of an illuminated window, surrounded by the many books that are piled up in the room. The print was much admired for the atmospheric way in which Rembrandt had rendered this studious environment, and for its astonishingly rich, deep tones.

Rembrandt completed several other commissions for Six, including an etched frontispiece for the publication in 1648 of Six's most famous play, *Medea*. He also created two etchings in 1652 for Six's *Album Amicorum*, and there was even a large and powerful portrait in oils in 1654. Shortly afterwards, though, the friendship seems to have cooled. In 1655, when Six married the daughter of Nicolaes Tulp, he asked not Rembrandt but Flinck, Rembrandt's former pupil, to paint a portrait of his new wife.

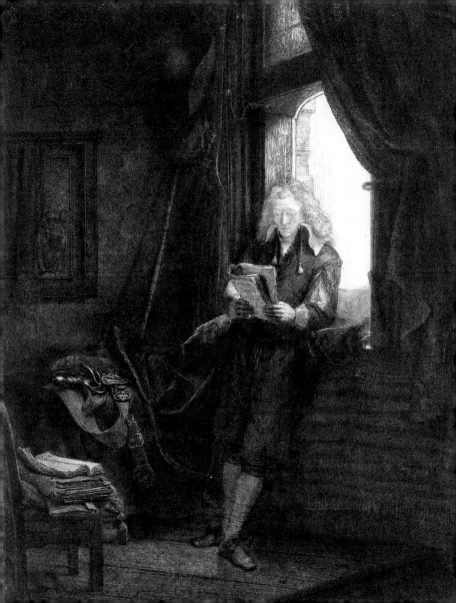

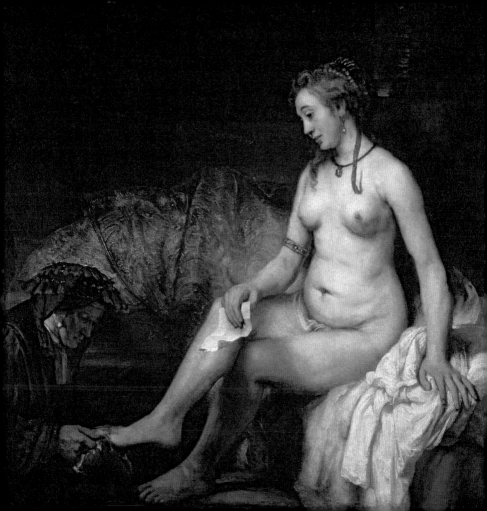

Money, sex and scandal

After the departure of Geertge, Rembrandt's home life did settle down, and the partnership with Hendrickje provided a loving, supportive and stable home for the young Titus. But financial trouble continued to plague them.

During the 1650s Rembrandt had a good income from his many pupils and from several important commissions. His etchings were also bringing in money. But he was still spending much more than he was making. There were the expensive mortgage payments on his home and the large sums he recklessly spent adding to his many collections. He was also still engaging in speculative ventures – one document records 'losses by sea'. By now he had considerable debts.

For a period, Rembrandt was successful in keeping his creditors at bay – including Thijs, to whom he still owed the alarming amount of 8,470 guilders for the house more than ten years after buying it. But circumstances were about to change. In 1653 the city of Amsterdam itself was in financial trouble because of the Anglo-Dutch war that had broken out a year earlier over competition for trade. The English had established a blockade that brought considerable hardship to the Dutch economy. Recession followed, and Rembrandt's creditors began calling in their loans. Rembrandt simply didn't have the available funds. All he could do was attempt to borrow more money from other people – including 1,000 guilders from Jan Six – in order to meet these demands. But it was a hopeless situation.

Also during this period Hendrickje fell pregnant and was therefore open to public reproach – records show that in 1654 the Amsterdam Council of the Reformed Church, of which she but not Rembrandt was a member, charged her with immoral cohabitation. Rembrandt's biblical painting *Bathsheba with King David's Letter*, also of 1654 – one of many non-erotic studies of the nude dating from the 1650s – seems to reflect movingly on the couple's personal lives. Here Hendrickje, who is the likely model, portrays the beautiful but married Bathsheba being unwillingly summoned into an adulterous liaison with King David. The liaison results in pregnancy, and David commissions the murder of Bathsheba's husband in order to cover his tracks. But for Rembrandt and Hendrickje the outcome was good. Their daughter, again named Cornelia, was born safely – a half-sister to Titus, who was now about 13.

Insolvency

By 1656 the seriousness of Rembrandt's financial situation was irreversible, and on 17 May he was forced to file for insolvency. This was in spite of the fact that he was still receiving and being paid for important commissions, and it gives some idea of the vast sums he owed.

Rembrandt managed to raise enough money to have the deeds of the Jodenbreestraat house transferred from Thijs to himself. But he still owed Thijs money. In an attempt at canny, but nonetheless legal, damage limitation, he quickly arranged for these deeds to be transferred to his son. Titus was now 15 years old, and one Louys Crayers was appointed his legal guardian to shield him from his father's financial affairs. Crayers would later win a court case ensuring that Titus' part of Saskia's inheritance lost in the insolvency was returned to him.

Inventories of all Rembrandt's possessions were drawn up – they are now invaluable art-historical documents – and over the next three years, the house and his extensive collections were auctioned in a series of sales. The only items not sold were the painterly tools of Rembrandt's trade. Rembrandt continued to work and to teach throughout this period, but the money raised by these auctions and the income from the sale of his own paintings and etchings as well as the fees paid by his students were insufficient to cover the remaining debts. And, distressingly, there is evidence that during this period Rembrandt was *still* over-spending. Saskia's relatives were, justifiably, worried that he was using up the inheritance that Saskia had left to Titus.

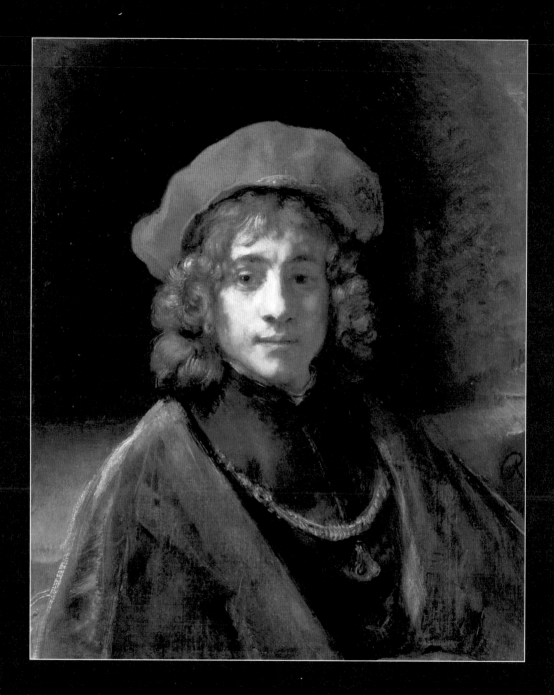

Titus

Rembrandt, c. 1657

Oil on canvas, 68.5 × 57.3 cm (27 × 22½ in)
Wallace Collection, London

Titus

And so to Rembrandt's beloved son, whom he had immortalized in so many drawings and paintings throughout the boy's life. A portrait of about 1657, more or less at life size, is profoundly moving because it was created while their home and possessions were being sold off. Titus must have felt the strain deeply; we see this from the sad and serious gaze that makes him seem older than his 16 years. He is a young man who has suddenly and of necessity taken on unexpected burdens and responsibilities.

Besides having the deeds to the Jodenbreestraat house in his name, Titus had three wills made between 1655 and 1657, at his father's instigation. In the light of Rembrandt's precarious financial situation, this was first of all to safeguard the money Titus had inherited from his mother. But it was also to ensure that, should Titus die without producing any children, his father would be his sole heir. Rembrandt's painting declares how keenly aware both father and son are of this situation. But it also testifies to the strength and closeness of their relationship.

To the Rozengracht

Inevitably, Rembrandt, Hendrickje, Titus and young Cornelia had to leave their home on the smart Jodenbreestraat. It is unclear exactly when the move was made, but at some point after May 1658 and certainly by August 1661 they had relocated to a much more modest house on the Rozengracht on the western side of the city, in a newly built neighbourhood known as the Jordaan. This workers' district was home to a number of artisans and shopkeepers. Several painters, including Rembrandt's old studio partner Lievens, also lived in the area, and it was developing into something of a new artists' quarter. (Lievens had returned from abroad and settled in Amsterdam in 1644, but it is not known whether he and Rembrandt renewed their acquaintance.) Rembrandt's new home, which cost 225 guilders a year to rent, was fairly pleasant – it faced a canal and a small park. But the area was in essence a working-class neighbourhood, overcrowded and dirty in parts, with poor accommodation.

During this final period of his life, Rembrandt and his family worked hard at seeking to resolve their ongoing financial woes. As part of a complex legal strategy, Rembrandt had registered himself as a 'man of no property'. This meant that on paper he effectively became an employee of Hendrickje and Titus, who had set up a business partnership to manage his affairs, probably in December 1660. So Rembrandt produced paintings for sale in their art shop, and received room and board in return. It is fascinating to note from the records that he was immensely prolific. In 1661 his art production was at the highest it had been since his record year of 1634, when he was still a young painter in van Uylenburgh's shop. His fame also continued to spread abroad. Rembrandt still received pupils, although none of these would become as famous as the earlier ones. One of his last known pupils was a painter from Dordrecht named Aert de Gelder, who is known to have painted in Rembrandt's style. Nonetheless, Rembrandt remained poverty-stricken.

New friends and old

Rembrandt led a quiet life in the Rozengracht. He'd lost some important friends and patrons, but he did maintain contact with his vast network of acquaintances. The fact of Rembrandt's insolvency – which affirmed that his plight was caused by financial miscalculation and misfortune rather than dishonesty or even fraud – does not particularly seem to have been held against him, and Rembrandt would not have been the only one laid low by the recession. One of several painter friends with whom he kept in contact was the marine painter, industrialist and collector Jan van de Cappelle, who owned seven paintings and over 500 drawings by Rembrandt, possibly purchased at one of the auctions of his goods. Another friend was the poet Jeremias de Dekker, who praised what he called Rembrandt's 'ingenious, worthy spirit' and referred to him as 'the Apelles of the day', whose work surpassed that of Michelangelo and Raphael. Rembrandt also maintained strong friendships with members of the medical, scientific and clerical professions.

It seems that Rembrandt's new neighbourhood appealed to him. He had always had great interest in and sympathy for people from different backgrounds, and this continued to be an important aspect of his character to the end. Several old and new Mennonite and Jewish friends of the artist lived in this mixed community. One of the most beautiful paintings he produced during these last years is his large-scale *Two Moors* from about 1661. Although his great inspiration, Rubens, had created a similar work, Rembrandt's painting was probably executed from life. In cosmopolitan Amsterdam, and in the republic more generally, there lived people from many nations, including Africans and people of African descent from the Dutch colonies in America and the West Indies. What is unusual and admirable is that rather than treating his two models simply as an exotic subject, Rembrandt has created a double portrait that shows exquisite sensitivity and respect.

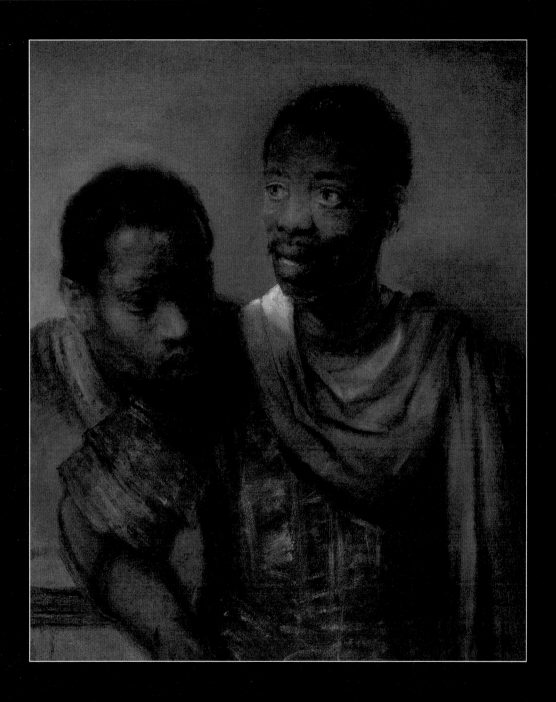

Two Moors
Rembrandt, c. 1661
Oil on canvas, 77.8 × 64.4 cm (30⅗ × 25⅛ in)
Mauritshuis, The Hague

Still the rebel

During the 1650s a new generation of art-buying merchants, burghers and patricians had come of age, and they were cultivating a new taste for refined and idealized works of art that were at odds with Rembrandt's psychologically compelling but often less than flattering style.

In 1681, some 12 years after Rembrandt's death, the poet Andries Pels would remark: 'He chose no Greek Venus as his model, but a washerwoman or peat-treader from a barn, naming his error truth to Nature, and everything else idle decoration. Flabby breasts, distorted hands, yes even the marks of corset-lacing on the stomach and of the stockings round the legs, must all be followed, or nature was not satisfied.'

The widespread mid-century taste for visual refinement meant, for instance, that sumptuous still-life paintings, known as pronkstilleven, were now in great demand. What a contrast to Rembrandt's own large painting of 1655 showing the carcass of a slaughtered ox hanging in a butcher's shop!

Several of Rembrandt's
former patrons, including
Jan Six, followed the new
shift in taste, and younger
artists inherited many
of Rembrandt's original
clientele.

An ill-fated commission

One of the most emphatic clashes in artistic vision and taste occurred over a rather unexpected commission that Rembrandt started working on, again in 1661 – unexpected because Rembrandt had not been the initial artist of choice.

On 29 July 1655 Amsterdam's long-awaited new Town Hall had opened, to replace the one that had burned down in 1652. Van Campen had designed the stunning neoclassical building, complete with a large cupola and enormous public and administrative spaces of shimmering white marble. Great paintings were commissioned to decorate the interior.

Jan Lievens was one of those to receive a commission, but the most prestigious went to Flinck. It was for eight huge paintings commemorating the founding of the Dutch Nation: the revolt of the indigenous Batavians led by Claudius Civilis against the occupying Romans. But Flinck died in 1660 with his project incomplete, and Rembrandt's name came up – perhaps van Uylenburgh had put in a good word. Rembrandt spent much of 1661 and 1662 completing his enormous *Conspiracy of Claudius Civilis*. At almost 5.5 metres (18 feet) square, it was the largest painting he had ever made.

But it didn't remain in situ for long. There are various stories about why the work was quickly removed from the Town Hall. In general, its expressive coarseness, indeed ugliness, was problematic, and Rembrandt's decision to depict the revered hero, Claudius, with his grotesquely scarred, blinded eye visible to all was deemed offensive. Down it came, and all that remains today is a fragment – admittedly a large one. Rembrandt is thought to have reduced the painting's size himself in an attempt to find a buyer. This was all the more urgent since it appears that he was never paid for his work. He was desperate for all the money he could get: that same year he was even obliged to sell Saskia's tomb in the prestigious Oude Kerk. Her ashes were moved to the Westerkerk, near to the Jordaan, where Rembrandt would also later be buried.

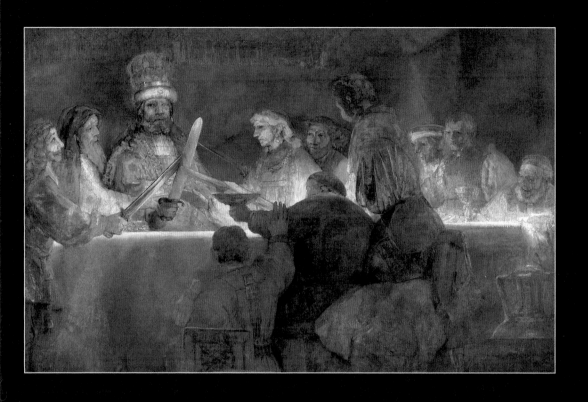

The Conspiracy of Claudius Civilis
Rembrandt, 1662

Oil on canvas, 196 × 309 cm (77 × 122 in)
Nationalmuseum, Stockholm

Remaining true to his principles

> 'When I want to refresh my spirits, I don't go
> looking for honours but for freedom.'

Whether Rembrandt really did utter these noble words is
unknown – but several authorities, including Houbraken and
the French painter and critic Roger de Piles, writing in 1699,
claim that he did. Certainly, the sensibility they express accords
with the personal, professional and artistic choices Rembrandt
seems to have made in later life. Unlike more decoratively
inclined painters – including Bol and Flinck – Rembrandt made
no attempt to sidle up to those in power. His ongoing technical
and compositional experiments with engraving and painting
challenged artistic norms and the prevailing taste in order to
convey what were for him the most thought-provokingly intimate
and deeply emotional stories possible. He didn't change his
style in order to please others or increase his popularity; he
continued to forge his own individual path. And a number of
important people valued that choice.

During the last years of his life, Rembrandt continued to be
sought out, if not by the city fathers then certainly by more
discerning and intelligent connoisseurs. He was commissioned
to paint at least one more important group portrait for the
Amsterdam Clothmakers' guild, and his foreign admirers
remained faithful – such as the Sicilian aristocrat and collector
Antonio Ruffo. (Although Ruffo and Rembrandt would ultimately
fall out as the result of a payment dispute.) Rembrandt even
received a visit from the most noble Cosimo III de' Medici,
son of Ferdinand II, Grand Duke of Tuscany, who arrived at
Rembrandt's small house on 27 December 1667, retinue in
tow, while on his Grand Tour of Germany and the Netherlands.
Although no sales or commissions ensued, this showed that
Rembrandt had become an Amsterdam tourist attraction.

Another great loss

On 24 July 1663 Hendrickje died. She was only in her late 30s, and was buried in a rented grave in the Westerkerk. She died of the plague, as did many other Amsterdammers that year. One of the negative effects of the city's great trade by sea was that not only riches from around the globe were imported, but also pestilence-carrying vermin. In 1656, for instance, records show that 18,000 of the city's inhabitants had died; in the latter part of 1663 that figure was 10,000, and in 1664 a terrifying 24,000 – almost one-fifth of the population. Although the whole of the city was affected, the poorer and less sanitary Jordaan district was especially hard hit.

Rembrandt had lost another soulmate, and the person upon whom, along with Titus, he now depended in a practical, everyday way for whatever livelihood could be mustered. It is possible that Hendrickje had been unwell for some time, as she had gone to the trouble of making a will in 1661. She was, after all, the one who had to handle all the household's setbacks and financial anxiety.

With Hendrickje gone, all these practical affairs now rested on Titus. However, at 22 he was still a minor according to the terms of his guardianship, and this hampered his ability to take care of the family. He petitioned for legal independence and did finally receive his inheritance – although it was quite considerably depleted. Titus continued to act as his father's agent and was working, not altogether successfully, to stabilize his father's affairs. His plans for the future were to continue as his father's agent, selling art and curios in the shop he and Hendrickje had set up.

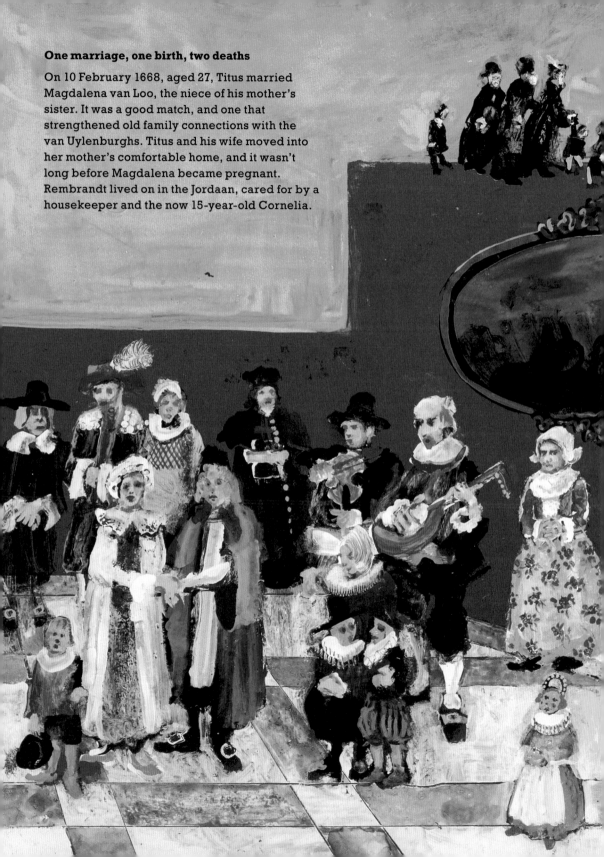

One marriage, one birth, two deaths

On 10 February 1668, aged 27, Titus married
Magdalena van Loo, the niece of his mother's
sister. It was a good match, and one that
strengthened old family connections with the
van Uylenburghs. Titus and his wife moved into
her mother's comfortable home, and it wasn't
long before Magdalena became pregnant.
Rembrandt lived on in the Jordaan, cared for by a
housekeeper and the now 15-year-old Cornelia.

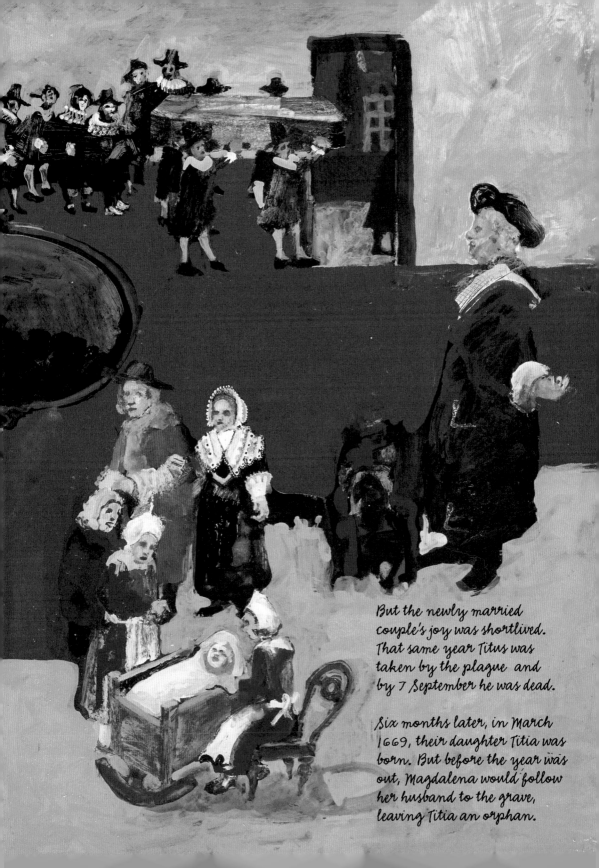

But the newly married
couple's joy was shortlived.
That same year Titus was
taken by the plague and
by 7 September he was dead.

Six months later, in March
1669, their daughter Titia was
born. But before the year was
out, Magdalena would follow
her husband to the grave,
leaving Titia an orphan.

What is left?

The year 1668 was possibly Rembrandt's most terrible. It is hard to imagine how he felt at the loss of his son – his closest friend and, as his business manager, his lifeline to any financial security. His only remaining child was the teenage Cornelia, although his granddaughter Titia would be born the following year. Both would indeed bring joy to his life, but neither was in a position to support it.

Rembrandt was old at 62. Fashions in art had passed him by, and of his former pupils, those who had gained fame by following the new trends had distanced themselves from their master. He was poorer than he had ever been in his life, and his prospects for the future did not look bright. Considering also that year by year the city was being decimated by the plague and the republic as a whole was undergoing a period of political and civic unrest, he could have been forgiven for simply putting away his palette and giving up.

But instead, in the little over a year left to him, Rembrandt completed arguably his greatest works. Foremost among these is his painting of the biblical parable of the prodigal son – a subject he had treated when he and Saskia were first married.

But this late work could not be more different. The earlier painting depicted the prodigal's life before he realized it had gone wrong. The work of 1668, by contrast, focused on the son's return to his father, destitute and looking for a safe haven. The father, abandoning all dignity and judgement, reaches down to embrace the son he had thought lost for ever. As the scholar Gregor J.M. Weber has put it, the scene is one of ultimate reconciliation. 'There is no sign here of any sudden transition from misfortune to good fortune ... Instead, the gentle act of reconciliation exudes permanence.'

Although we don't know when the painting was begun, it was probably completed after Titus' death. It is therefore impossible to look at this image without thinking of how it connects to Rembrandt himself. In his and Titus' relationship, who would be the father and who the prodigal son? Whatever the role, however, the power of the image is in its expression of repentance and redemption. The twentieth-century Dutch priest and contemplative writer Henri Nouwen has observed of the father's embracing hands that one is large and masculine, the other fragile and feminine.

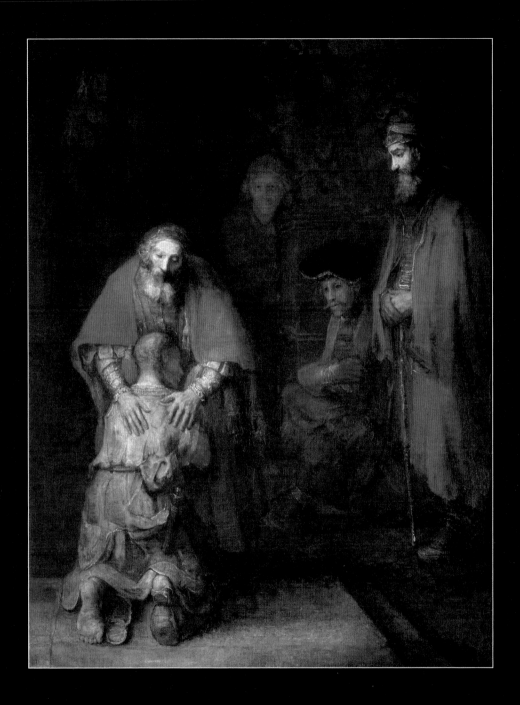

The Return of the Prodigal Son
Rembrandt, 1668

Oil on canvas, 262 × 205 cm (103⅛ × 80¼ in)
State Hermitage Museum, St Petersburg

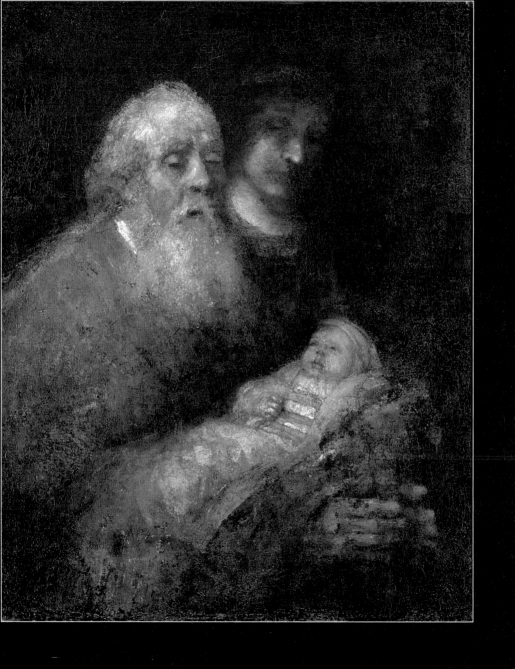

Simeon's Song of Praise

Rembrandt, 1669

Oil on canvas, 98.5 × 79.5 cm (38¼ × 31⅛ in)

Nationalmuseum, Stockholm

Rembrandt's death

On 4 October 1669, a year after Titus, and six weeks before his daughter-in-law Magdalena, Rembrandt died. His last years were utterly impoverished, and there is evidence that in 1666 he had been unable to pay the rent that was due on the Jordaan house. Reputedly, he was also drawing on funds that belonged to Cornelia and, according to Magdalena, also his granddaughter, Titia.

But Rembrandt was honoured in death. No fewer than 16 coffin bearers carried him to his final resting place in the Westerkerk, where so many of his family had preceded him.

At his death, an inventory of his studio was drawn up, and it included a group of 22 works described as 'both finished and unfinished'. One of the unfinished pieces is *Simeon's Song of Praise* of 1669. It is a biblical theme he had drawn and painted several times. It focuses on the aged Simeon as, with exquisite care, he holds the infant Jesus, who has been brought to the temple by his parents to be presented and blessed in accordance with the Jewish custom. Illuminated fragments of Mary's face – possibly completed by an unknown artist – emerge subtly from the intensely dark background. Simeon had been told by God that he would not die before he had seen the Messiah, or saviour, with his own eyes. Rembrandt depicts the moment when Simeon utters: 'Sovereign Lord, as you have promised, you may now dismiss your servant in peace. For my eyes have seen your salvation, which you have prepared in the sight of all nations ...' This painting was a commission, and therefore neither the choice of subject nor the sentiments portrayed should necessarily be interpreted as mirroring Rembrandt's own feelings. But it is hard to look at the painting and not think of the grandfather Rembrandt holding little Titia. In it, once again, a condition of unequivocal peace and fulfilment is expressed.

'The wonder of our age'
Gabriel Bucelinus

From the outside, the shape of Rembrandt's life can be seen as a vertiginous rise followed by a tremendous and shattering fall. But the perspective on his inner life given by his works tells a very different story, one of a brash, ingenious and precocious youth maturing into a considered, perceptive and thoughtful man. The contrast between that exterior and interior view simply reinforces the impression of Rembrandt's gloriously stubborn and rebellious nature. He kept to his principles no matter what fate threw at him. He was a gifted but by no means perfect man, who was determined to keep overcoming the obstacles that came his way – although many of them were self-inflicted. He ended his life knowing that he had continued, without diversion, on his chosen path.

By the time of his death Rembrandt's work had already met with some disfavour. During the remainder of the seventeenth century and throughout the eighteenth several critics would heap that opprobrium higher. His style fitted neither the decorative fantasies of the high Baroque and the subsequent Rococo nor the austerity of neo-classicism. But when modern art developed in the nineteenth and twentieth centuries, fired by its rejection of academic ideals, Rembrandt's emotive line- and brushwork, with all its psychological intensity, was applauded. His drawings, paintings and prints have stood the test of time.

Rembrandt created around 80 self-portraits, and these provide an incredible window on the man in almost every year of his adult life. In what is believed to be his final self-portrait, that of 1669, he presents a wrinkled and battered face and a gaze of unflinching and realistic self-appraisal. There is no trace of bitterness. There is sadness and loneliness, but also resilience, and even a trace of his youthful celebratory spirit. As confirmed by X-radiography, in this work Rembrandt was originally shown wearing his everyday white painter's cap. But he couldn't resist altering it into the colourful turban now visible, with flamboyant stripes of rich reds, browns and golds. Here, then, is his parting shot, a final crowning glory – hadn't he always loved a good hat?

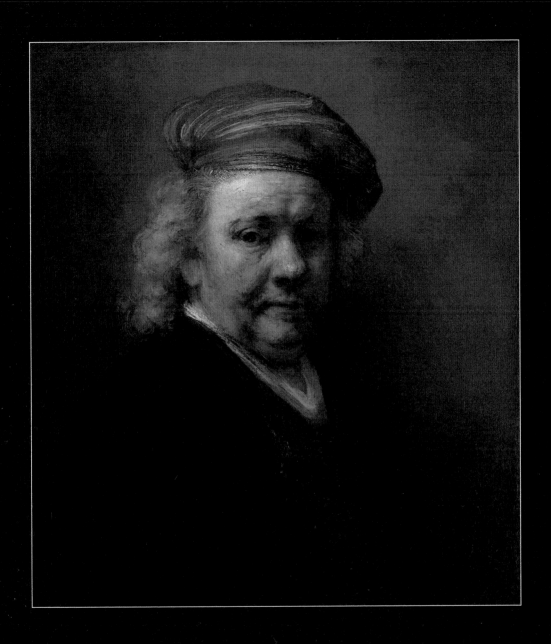

Self-Portrait
Rembrandt, 1669
Oil on canvas, 65.4 × 60.2 cm (25¼ × 23⅝ in)
Mauritshuis, The Hague

Acknowledgements

With gratitude to my parents, Clive Andrews and Anna Andrews van de Laak, for first introducing me to the glories of art; and thanks to Nick Higgins for his unusual and evocative illustrations, to the ever-inspirational Catherine Ingram for her support, and to Donald Dinwiddie, Felicity Awdry, Alex Coco, Julia Ruxton and Felicity Maunder at Laurence King Publishing for the care and insight they have poured into this publication.

Bibliography

Alpers, Svetlana. *Rembrandt's Enterprise: The Studio and the Market.* London and New York: Thames and Hudson, 1998.

Bailey, Anthony. *Rembrandt's House: Exploring the World of the Great Master.* London: I.B. Tauris & Co., 2014 (1978).

Bikker, Jonathan, and Gregor J.M. Weber. *Rembrandt: The Late Works.* London: National Gallery Company, and Amsterdam: Rijksmuseum, 2014.

Brown, Christopher, Jan Kelch and Pieter van Thiel (eds). *Rembrandt: The Master and His Workshop.* London: National Gallery Publications, 1991.

Crenshaw, Paul. *Rembrandt's Bankruptcy: The Artist, His Patrons, and the Art Market in Seventeenth-Century Netherlands.* Cambridge and New York: Cambridge University Press, 2006.

Schama, Simon. *Rembrandt's Eyes.* London: Allen Lane/The Penguin Press, 1999.

White, Christopher. *Rembrandt* (World of Art). London and New York: Thames and Hudson, 1984.

White, Christopher. *Rembrandt as an Etcher: A Study of the Artist at Work.* New Haven and London: Yale University Press, 1999.

Jorella Andrews

Jorella Andrews is a senior lecturer in the Visual Cultures department at Goldsmiths, University of London, and the author of *This is Cézanne* and *Showing Off! A Philosophy of Image.* Having trained as a fine artist and then as an art theorist, she is interested in the relations between philosophy, perception and art practice.

Nick Higgins

Nick Higgins is a London-based illustrator with many clients in publishing and advertising, including *The New York Times*, *The New Yorker*, The Royal Shakespeare Company and the BBC World Service.

Picture credits

All illustrations by Nick Higgins

4 Germanisches Nationalmuseum, Nuremberg, Germany / Bridgeman Images; **10** Private Collection / Photo © Christie's Images / Bridgeman Images; **11** White Images / Scala, Florence; **13** Photo Scala, Florence; **15** Photograph © 2016 Museum of Fine Arts, Boston; **18** Rijksmuseum, Amsterdam; **21** Ashmolean Museum, University of Oxford / Bridgeman Images; **22, 28** Rijksmuseum, Amsterdam; **29** Photo © Mauritshuis, The Hague; **32** Photo Scala, Florence / bpk, Bildagentur für Kunst, Kultur und Geschichte, Berlin / Photo: Jörg P. Anders; **37** Gemäldegalerie Alte Meister, Dresden / © Staatliche Kunstsammlungen Dresden / Bridgeman Images; **38** © The National Gallery, London / Scala, Florence; **44–45, 46, 47, 51, 52, 55** Rijksmuseum, Amsterdam; **56** Musée du Louvre, Paris / Bridgeman Images; **61** © Wallace Collection, London / Bridgeman Images; **65** Photo © Mauritshuis, The Hague; **69** © Nationalmuseum, Stockholm, Sweden / Bridgeman Images; **75** akg-images; **76** © Nationalmuseum, Stockholm, Sweden / Bridgeman Images; **79** Photo © Mauritshuis, The Hague.